Bishop Burton
COLLEGE

141

D1389152

SEEING THINGS SIMPLY
COMPOSITION

LESSONS & EXERCISES TO DEVELOP
YOUR PAINTING & DRAWING TECHNIQUE

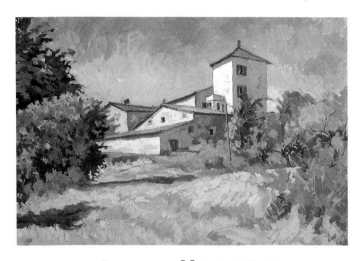

JAMES HORTON

A QUINTET BOOK

Published by The Apple Press
6 Blundell Street
London N7 9BH

ISBN 1-85076-505-7

This book was designed and produced by
Quintet Publishing Limited
6 Blundell Street
London N7 9BH

Creative Director: Richard Dewing
Designer: Ian Hunt
Project Editor: Helen Denholm
Editor: Hazel Harrison
Photographer: Paul Forrester

Typeset in Great Britain by
Central Southern Typesetters, Eastbourne
Manufactured in Singapore by
Bright Arts (Singapore) Pte Ltd
Printed in China

CONTENTS

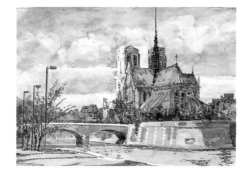

INTRODUCTION

MANY AMATEUR PAINTERS have a rather negative – and sometimes even hostile – attitude to the word "composition". They see it either as something which is beyond their capabilities or as a kind of "frill", less important than the business of creating realistic effects in paint. In reality, composition only means organizing the picture so that you get the best out of the subject you have chosen, and for many artists this is the most enjoyable part of the painting.

All good paintings are composed, whether consciously or unconsciously. The Impressionists were fond of claiming that they painted exactly what they saw, and indeed they did, but they still considered which viewpoint to paint from, what shape the painting should be, where to place the horizon, how to treat the foreground and so on. When I paint a landscape on the spot,

as I frequently do, I plan my picture in the same way. If I am working in oils I always begin with a brush drawing to work out the composition.

If you are working direct from a landscape subject you can only compose with what you see before you, but for studio paintings you have more leeway because you can arrange the subject as you choose. In the first part of this book I have dealt with what might be termed "rearranging nature", while in the second I have provided some ideas on composing portraits, still life and floral groups by planning the initial set-up as well as the painting itself. I have also explained some of the more formal rules of composition based on geometry – most artists are aware of these and you may find them interesting even if you do not see an immediate application to your own work.

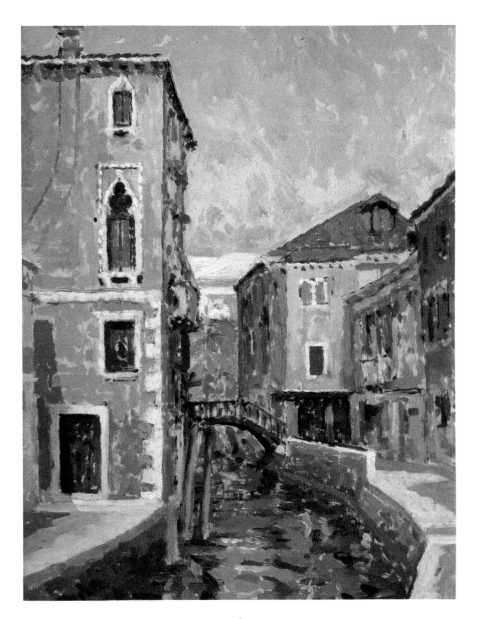

CHOOSING THE VIEWPOINT

PAINTING IS A CONTINUOUS PROCESS of decision-making. When you are confronted with a landscape subject, the first and most important decision is what viewpoint you will take and which part of the landscape you will concentrate on. When you look at a scene you unconsciously "pan around" with your eyes, taking in much more than will fit on the rectangle of your

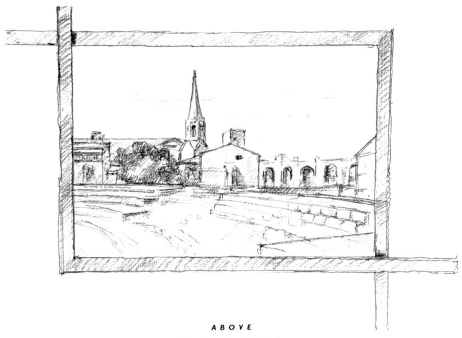

A B O V E
*The closer the viewfinder is
to your eyes, the more of
the scene you will see.*

working surface, so you must learn to be selective. A viewfinder is a great help here, as you can use it to isolate parts of the scene and make things less confusing. You can buy viewfinders, but they can also be made very easily by cutting a rectangular aperture in a piece of card. Hold it up in front of you, at different distances from your eyes and at different angles, and you will be able to explore the various possibilities of what to include in your painting. The viewfinder should always have the same proportions as the canvas, board or paper you are using.

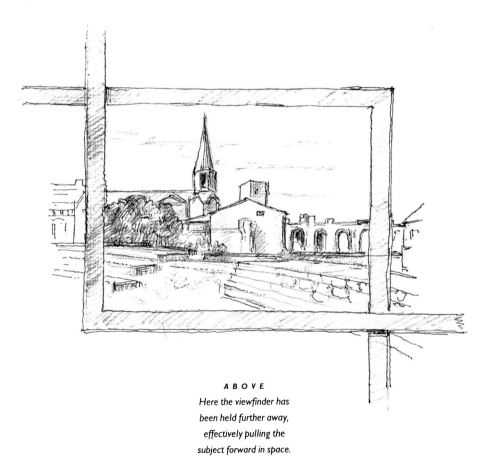

ABOVE
Here the viewfinder has
been held further away,
effectively pulling the
subject forward in space.

THE ANGLE OF VIEWING

THE ANGLE AT WHICH you see the view has a more dramatic effect than you might realize. Often a landscape that looks exciting when you are walking around becomes dull when you sit down – or vice versa. A low viewpoint will give a more obvious foreground. For example, in a flat landscape something relatively tall in the foreground, such as a shrub or clump of grass, will dominate the view, while from a standing position you might barely notice it. If you move slightly to the right or the left you will also see marked differences, so before you begin to paint or draw, walk around and make sure you have chosen the best possible position to work from.

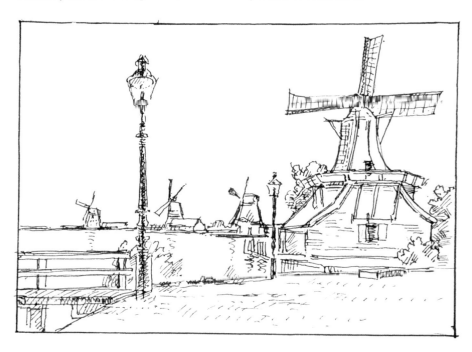

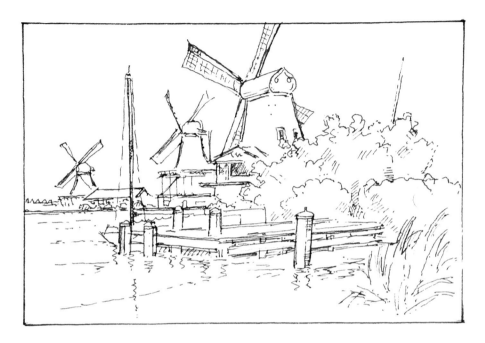

*Both of the drawings shown here are
different views of the same subject. The one
above is seen from a sitting position – notice
the prominence of the foreground. In the
drawing opposite I have moved to the left,
revealing additional elements on this side
and excluding some of those on the right,
such as the trees in front of the windmill.*

AVOIDING SYMMETRY

THE BASIC RULE of composition – though of course all rules can be broken on occasion – is asymmetry. It is not usually wise, for example, to place a horizon line directly in the middle of the picture, as this will divide the picture into halves and destroy the unity of the composition. You should also avoid placing an obvious focal point (see pages 16–17) directly in the centre. In a good composition, the eye should be led around the picture from one part to

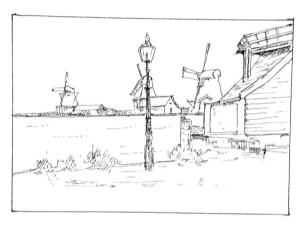

LEFT
The lampost divides the picture into two. It would be better positioned further over to the left, thus balancing the shapes of the building.

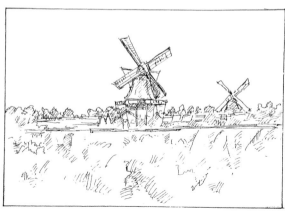

LEFT
Here the windmill is too central and would also be better moved slightly to the left.

10

another, and if an important element is placed too centrally all attention will be focused on this to the exclusion of anything else. In my two pen drawings on the left, showing "wrong" compositions, you can see the effect of

an over-symmetrical approach. In the bottom drawing the central placing of the windmill is slightly less obvious because the smaller one on the right acts as a balance, but it is still not satisfactory.

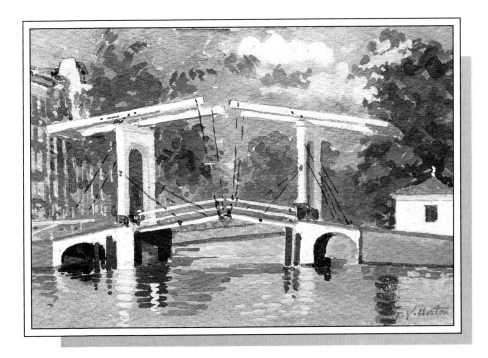

ABOVE
In this watercolour sketch I have
avoided symmetry by placing the
bridge slightly off-centre.

11

CHOOSING THE FORMAT

ONCE YOU HAVE CHOSEN the viewpoint there is another decision to be made – what format, or shape, the painting should be. To some extent this will depend on the subject. For example, a wide expanse of sea and sky would usually demand a horizontal emphasis. But although the traditional format for landscape is a horizontal rectangle, there is no reason why you should not choose a vertical rectangle or a square. In these three watercolours of the same subject, I have explored various possibilities. You may find it useful to make a few sketches before you begin to paint as this will help you decide on the best shape, or you can use the viewfinder system shown on pages 6–7.

RIGHT
The upright rectangle makes the most of the dramatic near-triangle of the cliff.

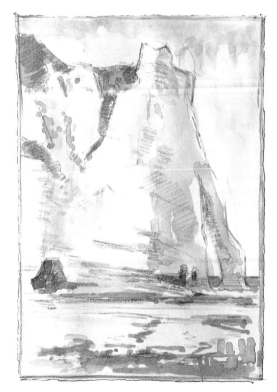

12

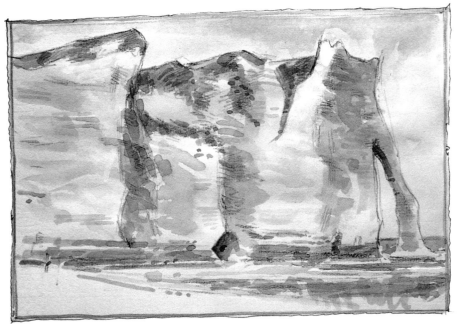

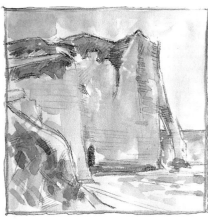

ABOVE
Using the traditional
landscape format, I was
able to include more of the
cliffs, but this has reduced
the impact of the triangular
formation.

LEFT
The square has allowed me
to accentuate the curving
line on the left.

CHANGING THE FORMAT

POOR COMPOSITION is one of the most common faults in landscapes done on location. Halfway through a painting you will often find that you have placed something too centrally, that a tree or building is uncomfortably near the edge of the canvas or paper, or that you have left out something interesting on one side or the other. If you are working in oils on canvas or board there is not a great deal you can do about this except start again. However, if you are drawing, or painting in watercolour or pastels, you can take a more flexible approach, either by leaving generous margins of paper and allowing the composition to grow, or by adding pieces of paper at the sides, top or bottom, as I have done in the painting shown opposite and below. As long as the paper is relatively thin and you join it carefully on the back, the joins will not show.

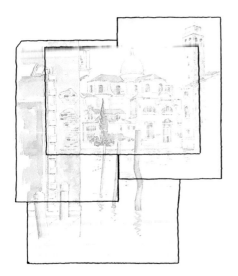

LEFT

This shows where further pieces of paper have been joined onto the original one. This paper is quite thin; it would be more difficult to join standard watercolour paper.

OPPOSITE

Having begun by focusing in on the central group of buildings, I found I needed more space in order to take in the top of the tower. I then expanded the composition further to include the wall on the left and more of the water, posts and reflections.

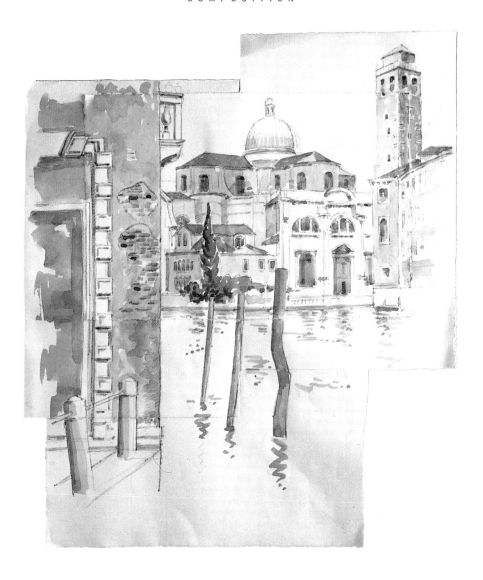

THE FOCAL POINT

NOT ALL LANDSCAPES have a focal point or centre of interest, but many do. Indeed, without fully realizing it, you may choose a particular subject because of some dominant feature. Focal points can be very obvious or very subtle. If you put people in a landscape – or even one small figure – they will automatically become the focal point because our attention is always taken by something familiar. For this very reason including people in landscapes can be a problem – they have to be "kept in their place" if they are not to dominate the composition.

Strong contrasts of tone are also attention-grabbers, so if you put a small white house in the middle distance of a relatively dark landscape it will become the focal point. Examples of more subtle focal points might be a gleam of light on a hill, a group of trees in the middle distance, a pale tree set against darker ones or a pattern of shadows.

O P P O S I T E

The white balconies immediately catch the eye, and are echoed by the reflections, thus extending the focal point to the whole central area of the picture.

16

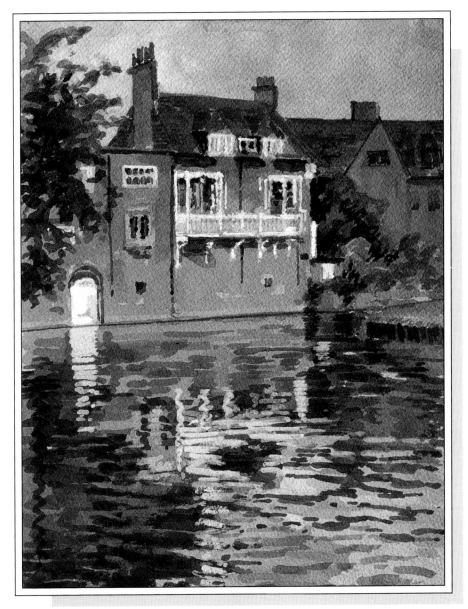

STRESSING THE FOCAL POINT

EVEN IF THE FOCAL POINT is fairly obvious, you will usually need to emphasize it and direct the viewer's eye towards it, and you can do this by setting up a series of visual "signposts". Examples of these might be a curving path or stream which leads the eye in towards the focal point, or perhaps the branch of a tree in the foreground. Diagonal lines are also very effective, and in urban

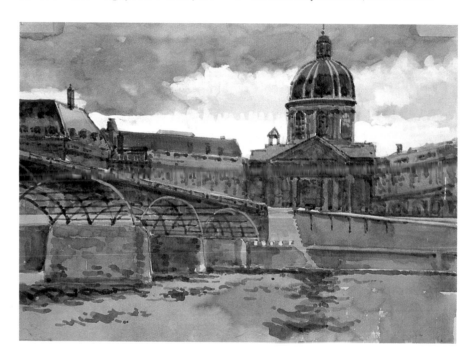

A B O V E
The building, with its fine dome, is the focal
point, accentuated by both the bridge and
the light area of sky behind it.

18

landscapes these will be provided for you if you choose the right viewpoint – because of the laws of perspective, any straight lines receding from you will become diagonals. In my painting of a Parisian scene (left), the bridge forms a diagonal leading towards the building, while in the painting of the drawbridge in Amsterdam (right), I have used both diagonals and curves.

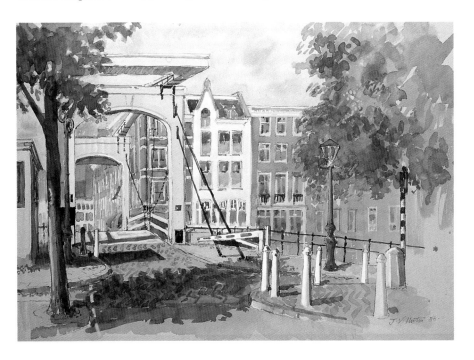

A B O V E

Here the tall drawbridge is the focal point, with the curves of the road and the diagonals of the cables guiding the eye towards it and then upwards.

19

CREATING MOVEMENT

IN A GOOD PAINTING the eye should be led from one part of the picture to another, so that one has almost the feeling of walking around in the landscape. This is what is called creating "a sense of movement" in the composition. A landscape composed with a predominance of horizontal lines can look very dull and monotonous and added to this, horizontals can also have a blocking effect. This is simply because our eyes follow lines, and if they go from one side of the painting to the other they lead the eye straight out of the picture rather than into it.

One of the commonest ways of introducing a sense of movement is to use curving lines leading from the foreground of the picture to the middle distance, as I have done in the paintings on this page. Even if the view you have chosen does not have such obvious features you can often slightly exaggerate something that is there or choose the viewpoint that provides the best "lead-in lines".

RIGHT
Curves lead the eye to the small bridge, whence it is taken upwards by the vertical of the building.

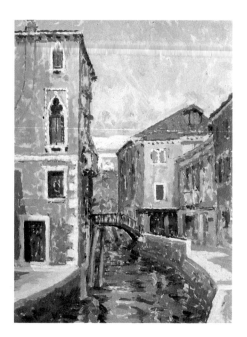

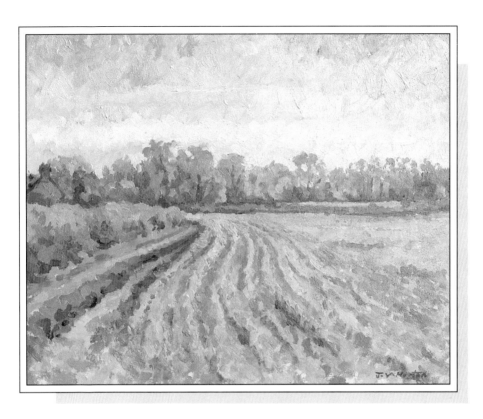

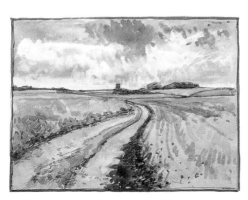

RIGHT
The sweep of the path leads the eye around the landscape.

ABOVE
Rows of planting in ploughed fields make excellent lead-in lines.

21

LIGHT AND DARK

AS WE HAVE SEEN, the focal point of a painting is often an area in which the contrasts of tone are strong, but tone is also important in the overall context of composition. Tone simply means the lightness or darkness of a colour, and a picture needs to have a good balance of tones or it can look dull and bland. This does not mean that you always have to paint on a bright sunny day when the contrasts between light and shadow are at their strongest. Some artists, notably the Impressionist Camille Pissarro, liked overcast weather which gives

ABOVE
Here the tones are close, with the
shadowed sides of the foreground trees
similar to the background.

gentler tonal transitions, but there must always be some contrast.

Using tone involves learning to analyse colours in terms of how light or dark they are, and this can be surprisingly difficult. It helps to half-close your eyes, which reduces the impact of the colour and lets you see things in a pattern of light and dark. If you see insufficient contrast there is no reason why you should not use some artistic licence and exaggerate a little, but do not overdo it or the painting will look false.

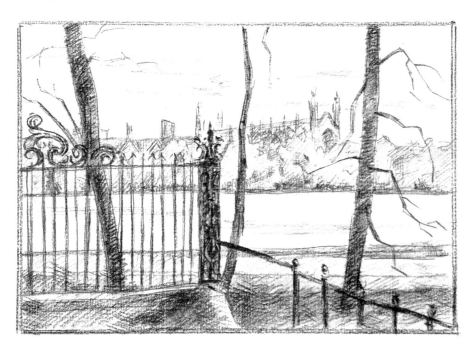

ABOVE
By darkening the trees and railings I have
made a more interesting tonal pattern.

FOREGROUNDS

FOREGROUNDS CAN OFTEN BE a problem in on-the-spot landscapes. Because this area is nearer to you than any other part of the scene you can see everything in sharp focus, which makes it difficult to decide what, if anything, to leave out. If you are faced with this problem, remember that composing a picture is a process of selection – you do not have to include everything you see. When the centre of interest is in the middle distance, as in my painting of a house in

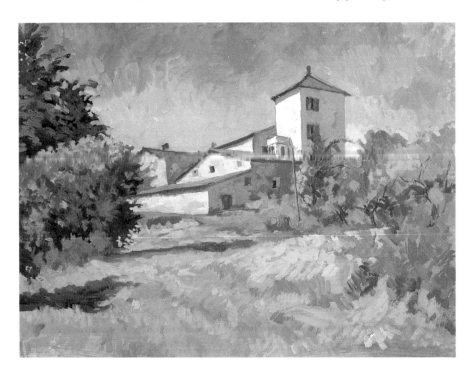

ABOVE

The foreground, although broadly treated,
contains sufficient visual interest, as I have
varied both the colours and the brushwork.

France (left), it can be best to generalize the foreground. In this case a lot of detail would have weakened the composition by focusing attention on what was of secondary importance.

It is important to see the foreground in the context of the painting as a whole, not as an isolated area. If there is something in the foreground that you particularly like – the foreground itself can be the centre of interest – you will obviously want to treat it in a more detailed way, but take care to make visual links between this and other areas of the picture. If you are working in colour, for example, you can often do this by a system of "echoes", perhaps using small patches of the blue used for a sky among the various greens of foreground grass.

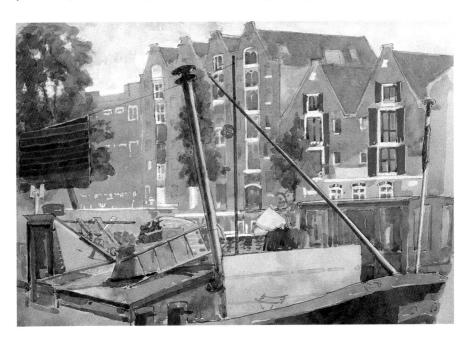

ABOVE
*Here the foreground is the main centre of
interest, with the buildings forming a
backdrop for the strong geometric shapes.*

COMPOSING WITH LIGHT

WHEN YOU ARE painting landscapes, choosing the time of day is every bit as important as any other advance decision, because light and shade can play a vital role in composition. If your subject is nearby or if you are staying in one particular place to paint, it is always worth making some preliminary explorations, as I did before painting the landscape opposite. With the light coming from the side and the sun relatively low, the shadows create a strong pattern of light and dark in the foreground, balancing the verticals of the trees. I have slightly exaggerated

this – notice that in the photograph taken at the same time the shadows are rather formless.

Skies are also important in composition, and on this occasion I was lucky enough to be provided with an interesting cloud formation which adds a further element to the picture. Because skies change so rapidly I always block in the shapes and colours of the clouds at an early stage in the painting, also paying attention to any patches of light and cloud shadow in the more distant areas of the landscape.

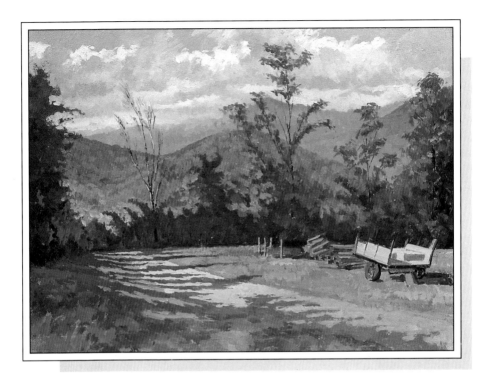

ABOVE AND OPPOSITE

The strong pattern of shadows in the foreground is vital to the composition, echoing the shapes of the trees and the movement of the clouds across the sky. By looking at the photograph opposite you can see how these were emphasized in the finished painting.

CLASSIC

LANDSCAPE COMPOSITIONS

THE THREE PICTURES shown here are watercolour sketches made from well-known oil paintings by artists who painted landscape on the spot – Claude Monet, Vincent van Gogh and Jean-Baptiste Corot. You can learn a great deal about composition by looking at the works of the Old Masters, perhaps making small pencil sketches to help you analyse the compositions.

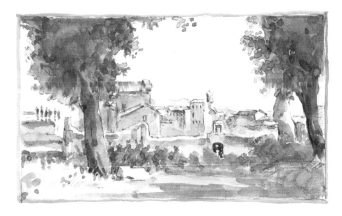

VIEW FROM THE FARNESE GARDENS
In View from the Farnese Gardens Corot has drawn attention to the focal point – the buildings – by using the trees as a "frame within a frame", a commonly used compositional device. Corot always liked to paint some way back from his subject, as he found that this simplified the forms and made it easier to organize the composition. Sometimes his foreground would be as much as two hundred yards from where he was positioned.

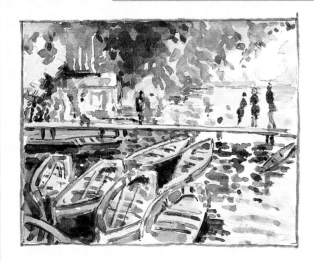

BATHING AT LA GRENOUILLÈRE

In Bathing at La Grenouillère *Monet has broken the rules by dividing the picture horizontally into near-halves, but the strong shapes of the boats in the foreground carry the eye into the painting towards the verticals provided by the three figures on the left.*

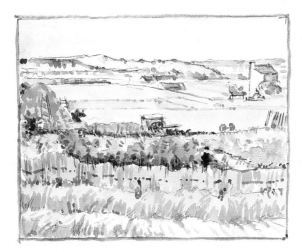

THE HARVEST

Van Gogh, too, has chosen a composition that would have defeated most amateur painters – a series of horizontal lines. However, the strong diagonal brush-strokes in the immediate foreground of The Harvest *work by leading the eye in, while the vertical strokes used for the grass and fence act as a counter-point to the horizontals.*

FORMAL COMPOSITION

WHEN YOU ARE PAINTING on the spot you can only compose with what you have, but for studio works the composition can be planned and organized at the outset. In this part of the book we look at this more deliberate way of working.

Throughout the history of art, there have been different kinds of composition. The so-called "classical" composition was based on harmony and balance, taking geometry as a starting point. These watercolour sketches from famous paintings show various ways of dividing the rectangle to provide this innate harmony. One of these was

the Golden Section, a proportion in which a rectangle is divided into unequal parts, with the ratio of the smaller to the greater part being the same as that of the greater part to the whole.

Geometry was used not as a formula but as an aid to constructing a picture. Here there is an analogy in music – the concerto and the symphony, for example, both have definite forms, but a concerto by Bach does not sound anything like one by Mozart. In the same way, no two Renaissance paintings look alike, even though they may both have the same geometric arrangement.

LEARNING FROM THE MASTERS

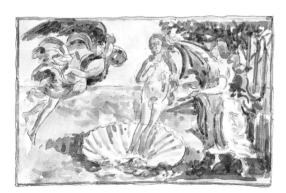

THE BIRTH OF VENUS
Botticelli's The Birth of Venus is one of the most famous examples of the use of the Golden Section in painting.

30

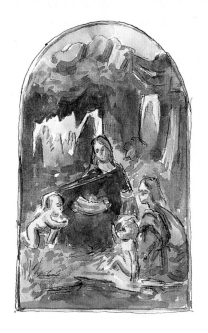

VIRGIN OF THE ROCKS

Leonardo's Virgin of the Rocks *is based on a triangle, which is still a common compositional device.*

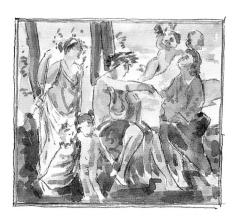

THE INSPIRATION OF THE POET

Here Poussin uses the division of the Golden Section on each side of the rectangle to govern the main horizontals, verticals and diagonals. This shows that the Golden Section is a very flexible ratio and does not have to be used within the standard Golden Section rectangle.

OTHER KINDS
OF COMPOSITION

CLASSICAL COMPOSITION is by no means dead; in many landscapes and portraits you will see the rectangle divided in the same ways as in a Renaissance painting. However, during the 19th century ideas on composition – and much else besides – began to change, and artists became more concerned with movement and dynamism than with harmony. These two watercolour sketches from well known paintings show contrasting approaches. One of the great innovators was Degas, who was much influenced by photography

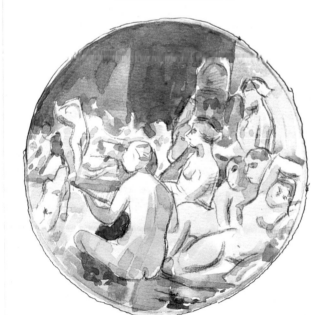

THE TURKISH BATH

The paintings of Ingres are firmly within the traditions of classical composition, and in The Turkish Bath he has produced a harmonious arrangement within a circle. Notice how he has avoided symmetry, placing the main figure off-centre. While using the right-hand group of figures to echo the outer curve, he has also "broken" the circle with verticals (the foreground figure and the dark area of background).

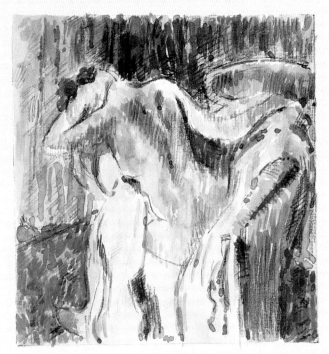

WOMAN WASHING

The composition in Degas' Woman Washing could not possibly be confused with a classical one. The figure, the swirling drapery and the diagonals at the right and left of the picture all create a strong sense of movement and dynamism.

and liked to create the impression of spontaneity as seen in a snapshot, often cropping his figures or painting them from unusual viewpoints. This kind of composition needs to be planned just as carefully as a painting based on geometry, and in spite of the effect given by Degas' paintings, they were very carefully structured. As he said himself: "Even when working from nature, one has to compose . . . No art was ever less spontaneous than mine."

VARYING THE FORMAT

WHEN YOU ARE PAINTING indoors you are in complete control of the composition: you can set up the subject as you choose, "designing" the painting in a more considered and methodical way than is possible when you are painting landscape on the spot. You can also experiment with different formats. If you have made landscape sketches or perhaps completed a painting you were not entirely happy with, it is often worth trying the same subject again indoors,

using a different format. You could find that a long, thin horizontal, as in my painting of Venice (below), suits the subject better than a standard landscape proportion.

Depending on the subject, you could try a more radical departure, composing within an oval or circle, as in my sketch of Ingres' painting on page 32, or even a triangle. Ovals and circles are often used for portraits in miniature, but they can also be effective for large-scale works.

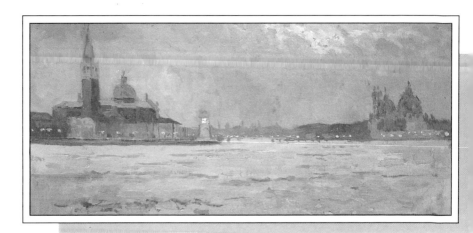

ABOVE
If I had worked on a standard shape I would have been forced to include more of the water in the foreground, or more of the sky, both of which would have reduced the impact of the buildings.

OPPOSITE
This tall vertical is a natural choice for a standing figure, particularly where the background is to be left undefined. A squarer shape would have required other elements, which I did not wish to introduce.

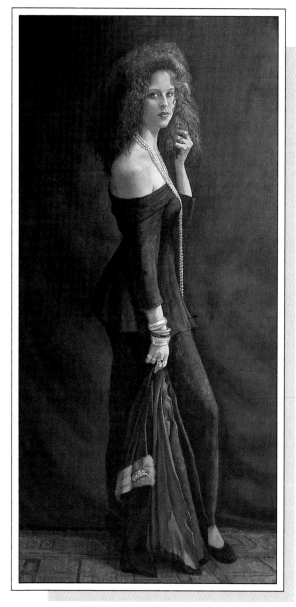

ARRANGING A STILL LIFE

STILL LIFE SUBJECTS give you the perfect opportunity for experimenting with composition – besides which, this is a very enjoyable branch of painting. You can work at your own pace, without the worries of dramatic changes in light, and you can choose whatever subject appeals to you. However, you must be prepared to spend time setting up a still life group, as this is the first and most important step in composing the picture.

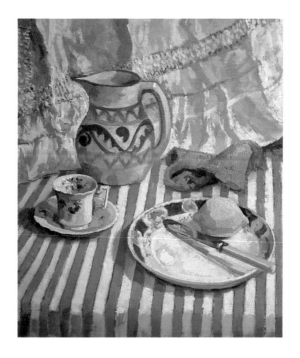

ABOVE

These objects gave me a pattern of circles and straight lines, with a curving diagonal in the background. I chose the colours carefully, with the orange and yellow providing contrast to the predominant blues.

There are no real rules about arranging a still life, but in general you want to aim at a natural effect; although still life is a highly artificial kind of painting it should not look that way. You also want to create some sort of pictorial relationship between the objects, so when you have chosen them, put them all down on the surface and rearrange them until you begin to see some sort of cohesion. Let some of the objects overlap, and place them at different positions in space, with some nearer the front of the table than others. As in landscape composition, you want to create a feeling of movement (see pages 20–1), to lead the eye through the painting from one object to another.

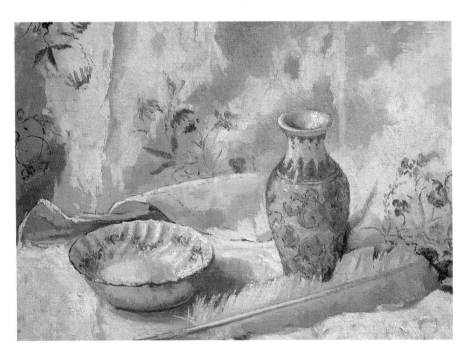

A B O V E

*I took some time arranging this simple group, particularly
with the background drapery, as I wanted the folds to
provide a balance for the feather in the foreground.*

EXPLORING THE OPTIONS

WHEN YOU HAVE SET UP your still life group you are still only halfway to composing the picture. Now you must decide what shape the painting is going to be, how you will place the still life on the paper or canvas, and what viewpoint you will paint it from. If you look at your group through a viewfinder (see pages 6–7) you may find that although you had originally envisaged it as a landscape shape it actually looks better in a portrait format (vertical rectangle). Here I have shown some of the many options presented by just one still life group.

The viewpoint is also important. A good rule is always to avoid horizontals, so if your group is on a table it is often better to view it from an angle so that the front and back of the table form diagonal rather than horizontal lines. You may also find that a high viewpoint, as you will have if you stand to paint, is better than an eye-level one. This is often the case if the group includes circles – plates or bowls, for example – as the ellipses (circles in perspective) will narrow into shallow ovals the nearer they are to your own eye level.

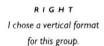

RIGHT
*I chose a vertical format
for this group.*

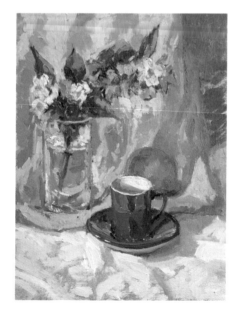

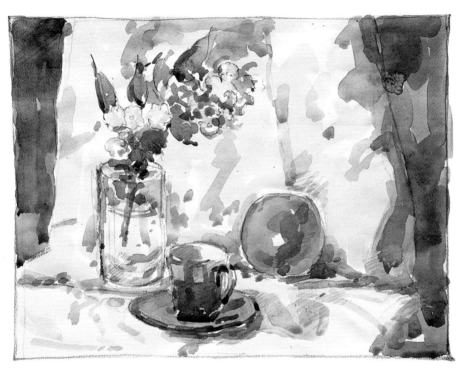

ABOVE

I could have painted the same group in a horizontal shape, thus making more of the background as shown here.

LEFT

Alternatively, I could have moved my viewpoint so that the vase of flowers occupied a more central position as in this sketch.

FLORAL STILL LIFE

FLOWER GROUPS present special problems; a flower arrangement that looks fine as a decoration in your home does not necessarily make a good painting. This is often because it is over-symmetrical, and therefore does not create the feeling of movement so vital in this branch of painting. You want to give the impression that flowers are living things. Another difficulty is that you often have areas of empty space at the sides of the vase, particularly if you are painting tall flowers, and you need to find some way of filling this space. A device often used in still life and flower painting is to arrange some drapery so that it curves around and in front of the vase to break up the flat plane of the table top. Sometimes a bowl of fruit or some other item is placed beside the vase to act as a balance; you can break off one of the blooms and put it on the table or, for a more natural look, simply scatter a few petals.

The photographs here, some of which show deliberately unsatisfactory arrangements, may provide some ideas.

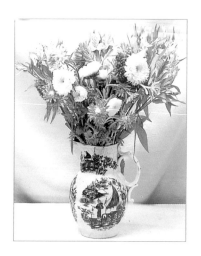

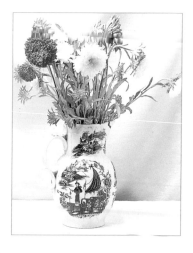

1 The flowers here are overcrowded and there is an ugly horizontal at back of table. A very dull, static arrangement.

2 A smaller number of flowers makes a better arrangement, with more movement.

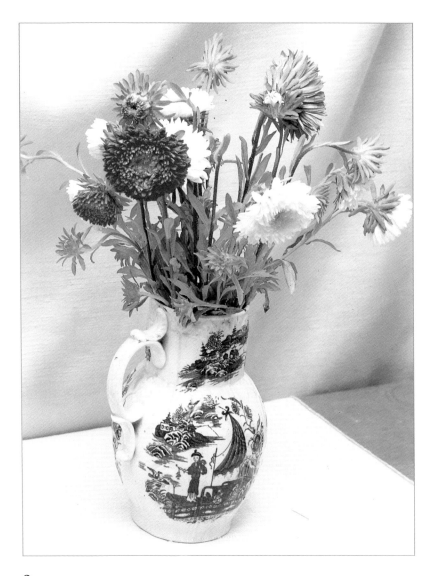

3 Moving the viewpoint so that the group is seen from an angle provides diagonals instead of horizontals.

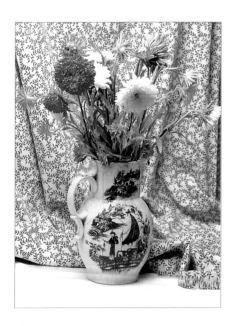

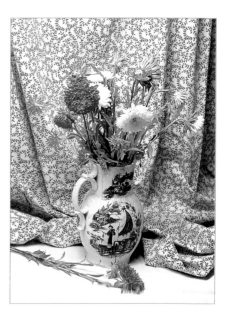

4 Drapery introduces more colour, pattern and movement.

5 The single flower fills in an area of blank foreground.

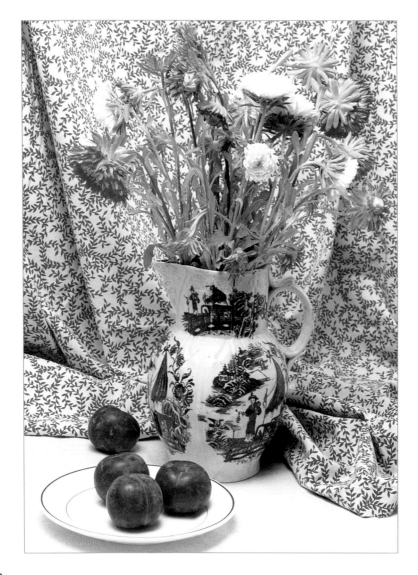

6 Circles made by the plate and plums balance the flowers. The plum at the back would have been better moved to the left.

FOUND STILL LIFE

SO FAR I HAVE BEEN discussing the kind of still life which is deliberately set up, requiring preparation and planning, but there is another kind of still life, often referred to as "found". Sometimes you will happen upon a ready-made still life group, which could be a collection of plates, glasses and cutlery left on a table after a meal, a pile of books lying on a chair or desk, objects arranged on a

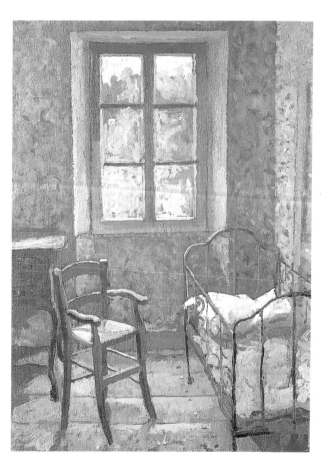

RIGHT

The child's cot and chair were brought in from another room and placed carefully on either side of the window. Notice that I have avoided symmetry by placing the window slightly off-centre.

mantelpiece, or even a group of stones on a beach – still lifes do not have to be painted indoors.

The corner of a room, or any interior with objects in it, is also a form of still life; one of the most famous of all examples is van Gogh's *Yellow Chair*. A still life in which the room itself is part of the composition obviously cannot be arranged and rearranged as drastically as a group set up from scratch, but you can move objects and pieces of furniture to improve the composition, and plan the picture, much as you would when painting a landscape.

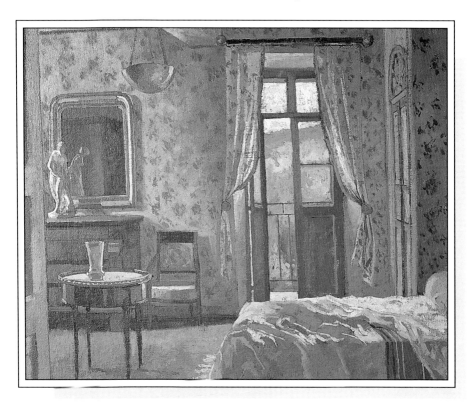

A B O V E

Light was an important element in this composition, so I
painted in several sessions, always at the same time of day.

45

CLASSIC STILL LIFE
COMPOSITIONS

STILL LIFE can take many different forms, and can be very simple or highly elaborate. During the 16th and 17th centuries in Holland very complex groups were much prized, and artists would vie with one another in their depiction of precious metals, silks and satins, flowers and foodstuffs. At the other end of the scale were artists such as Edouard Manet in the 19th century, whose still lifes were simplicity itself – one of Manet's paintings shows nothing but a ham on a plate with a knife in front of it. The watercolour sketches here, done from oil paintings by masters of still life show various approaches.

LEARNING FROM THE MASTERS

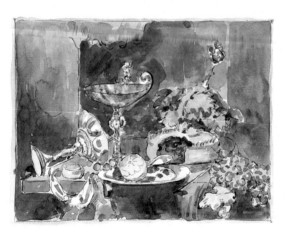

STILL LIFE WITH TAZZE AND A PIE

Jan Davidsz de Heem was one of the foremost of the 17th-century Dutch painters specializing in flower pieces and opulent still life groups. In Still Life with Tazze and a Pie the composition is based on a triangle. Notice how the artist has turned the silver goblet on its side so that the diagonal of the stem leads the eye in towards the gold one, the top of which forms the apex of the triangle, placed off-centre.

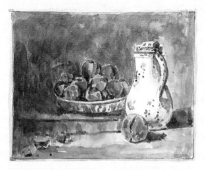

BOWL OF PLUMS AND WATER PITCHER

The still lifes of the 18th-century French painter Jean-Baptiste-Siméon Chardin show humbler objects. They were arranged to look as simple and natural as possible, but the simplicity is deceptive – his compositions were planned with great care. In Bowl of Plums and Water

Pitcher the eye is led through the picture in a circular direction, from the large fruit on the right through the jug, to the central bowl of fruit and then to the smaller fruits on the right. Because these are arranged in a diagonal row, the eye again follows them inwards, back to the centre of the picture.

THE MANTELPIECE

Edouard Vuillard, a French artist of the early 20th century, is known for beautiful and sensitive paintings of interiors – sometimes with figures – and "found" still lifes (see pages 44–5). This still life of objects on a mantelpiece is

very skilfully composed, with the verticals of the patterned wallpaper anchoring the diagonals of the mantelpiece, and a cleverly contrived triangle behind the bottles and flowers drawing the eye to this focal point.

PORTRAITS:
HEAD AND SHOULDERS

ALTHOUGH A HEAD AND SHOULDERS portrait is a relatively simple subject inasmuch as you do not have to juggle with a lot of different elements as you do in still life, the composition still needs to be planned. A portrait of this kind is unlikely to succeed if you put the head slap in the middle or if you "crop" awkwardly, either cutting off the body halfway down the neck or including too much of the body. The neck should always be included, as head and neck are one unit, and it is usual to crop below the neck or, if the sitter is wearing a garment with a low neckline, just below the point at which garment and body meet. If too much of the body is included, it can detract from the face.

A B O V E

This composition is a series of gentle curves, with the hair sweeping down on one side of the face to echo the curve of the cheek on the other.

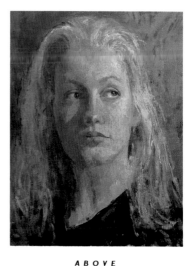

A B O V E

Lighting plays a vital role in this composition, with the strong illumination on one side of the face creating a pattern of light and shade.

48

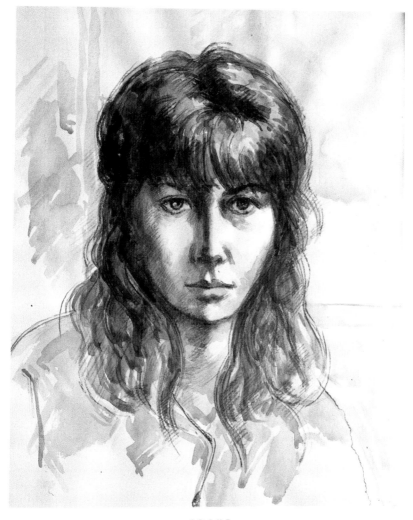

ABOVE

In this watercolour I have included more of
the body than is usual, but because I have
left much of it unpainted it does not divert
attention from the face.

49

PORTRAITS:
HALF-LENGTH

PORTRAITS WHICH INCLUDE HALF or three-quarters of the figure will naturally show the hands, and many portrait painters like to include hands whenever possible, as they can be as expressive and character-revealing as faces. Whether the figure is standing or seated, the usual convention is to cut off the figure below the hands so that the two areas of skin colour – the head at the top and the hands at the bottom of the picture – provide a counter-balance. You need to be careful here and make sure you have allowed enough space above the head as well as below the hands. If you crop the painting at the bottom just below the hands and leave a lot of space above the head, you will create an awkward impression, making the figure look as if it is being pushed downwards.

RIGHT
Sketches like this help me to plan the composition of my portraits. Here it has become obvious that I need to show more of the body below the hands.

OPPOSITE
In the oil painting I have cropped just above the knee, giving the hands, which are an important part of the composition, plenty of "breathing space".

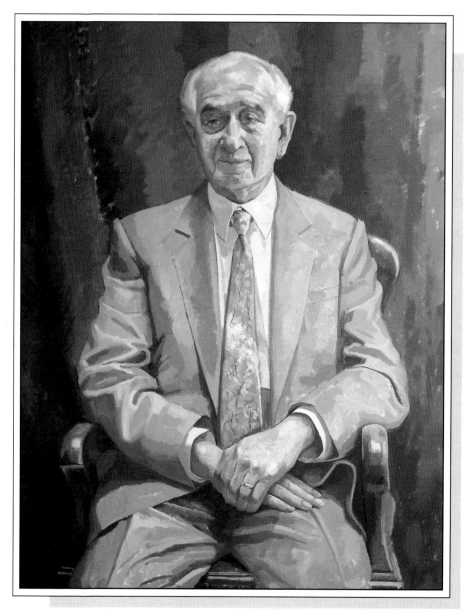

PORTRAITS: FULL-LENGTH

WHEN YOU ARE PAINTING a full-length figure you will have to make decisions about the background and setting. Basically there are two choices: you can either generalize the background, as I have done in the painting shown on page 35, or you can use the setting as part of the composition, as in this picture – a portrait of my sons done in our sitting room. In this way you can provide a context for the person or people, which can make for a better portrait as well as a more interesting composition. Portrait painters often use "props" in this way, sometimes showing their subjects with personal possessions or engaged in some characteristic activity. In a famous portrait of Emile Zola by Edouard Manet the writer is shown in his study, with an open book in his hand, and many earlier portraits included little still lifes explaining the sitter's profession, or his interests and enthusiasms. I have brought in this element also, making a still life out of the objects on the mantelpiece.

RIGHT

The main centre of interest is, of course, the figures of the boys, but the still life on the mantelpiece provides a secondary focus and ensures that there is visual interest in each area of the picture.

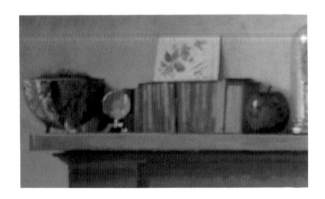

OPPOSITE

I did not want both boys standing, looking like a row of soldiers, so decided to have the younger one sitting on the rug. The two figures thus make a back-to-front L-shape, with the far side of the mantelpiece forming an inverted version of the same shape.

52

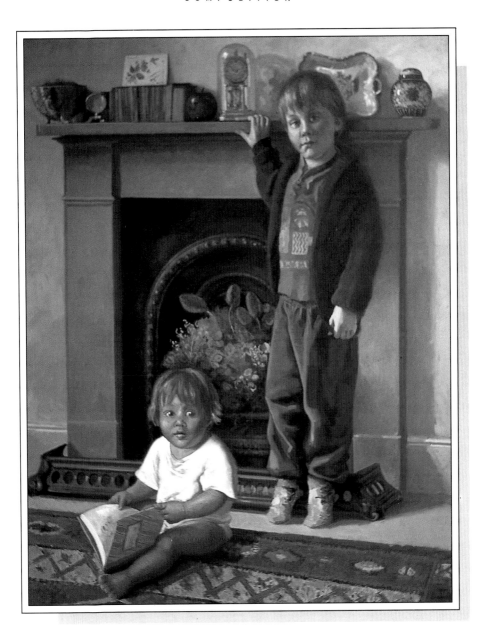

PAINTING THE NUDE

THE HUMAN FIGURE is such a difficult subject – particularly when undressed – that composition tends to be overlooked in the effort to get the drawing right. Another factor, of course, is that most people draw and paint the nude in life classes. Life studios, with their utilitarian chairs and ancient, battered sofas (if you are lucky) do not provide many inspiring elements for composition. However, if you are painting the nude rather than just drawing for practice, you must consider basics such as where you will place the figure, how much of it you will show and what you will use for background, if any. I like to treat the nude as I would a portrait, showing the model in the believable context of an ordinary room, as I have in these paintings.

RIGHT
The foreground chair almost joins onto the figure, so that the two together create a flame-like pattern swirling through the centre of the room.

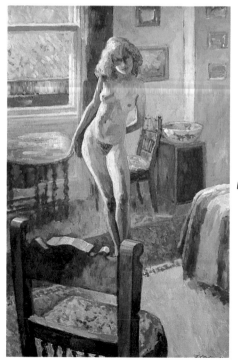

OPPOSITE
Here, too, there is a strong pattern element, with the curves of the body weaving through the verticals and horizontals of the room.

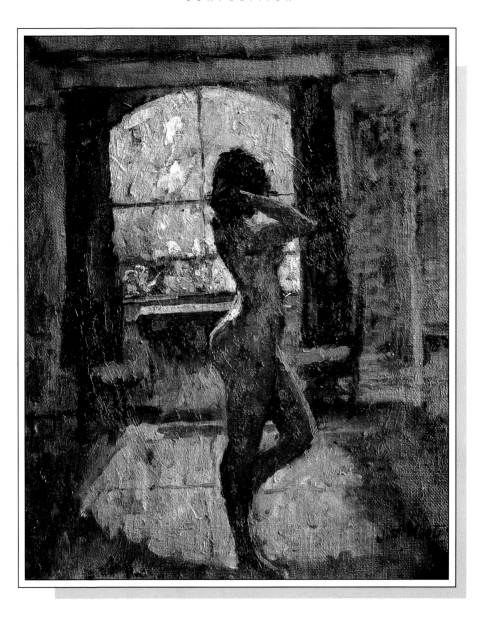

FIGURE GROUPS

IT HAS TO BE SAID that figure groups are not an easy subject, not least because you can seldom if ever paint directly from life. You will usually have to work from sketches made over a period of time, perhaps with the additional help of photographs. As far as composition is concerned, you have to consider not only the arrangement of the shapes and colours but also ways of expressing some sort of relation-ship between the figures – like a still

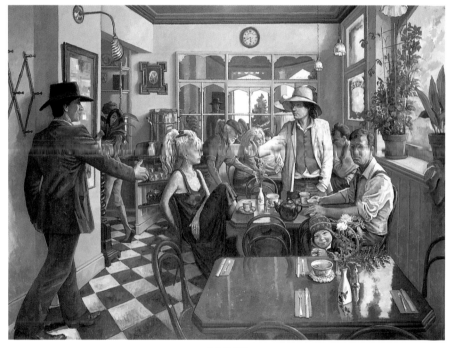

A B O V E

In this painting, composed from sketches and worked on over a long period, I have used the outstretched arms of the two standing figures greeting each other as a means of unifying the whole group.

56

life, a figure group must always have an overall cohesion.

In most figure groups you will see that the people have an obvious reason for being together – they may be engaged in some common activity, such as playing cards or sharing a picnic meal – but this "storyline" is not always enough in itself to provide the dynamic interactions that such a painting needs. If you are sketching a group pay particular attention to people's gestures and movements, as you can use these in your painting. One person leaning towards another, for example, will create a link between the two, as will an outstretched hand or a head turned to look at a neighbour.

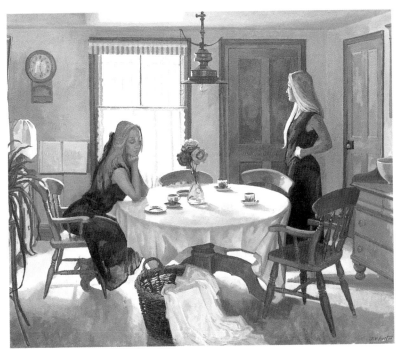

A B O V E

*Here the two women are linked not so much by a common
activity as by a shape – that of the round table, which
effectively "ties" them together. Circles are a natural eye-
catcher, and thus a considerable aid in composition.*

CLASSIC PORTRAIT AND FIGURE COMPOSITIONS

TWO OF THE THREE pictures shown here, all of which are watercolour sketches made from paintings by Old Masters, are half-length portraits (see pages 50–1). The third shows an unusual treatment of the figure, using a mirror to produce what is partly a still life and partly a nude study.

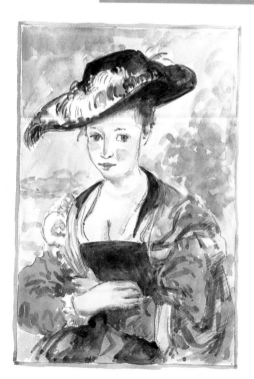

SUSANNA FOURMENT

Rubens' painting of his first wife's sister, Susanna Fourment, is quite simply one of the most wonderful portraits ever produced. It is interesting that the composition was allowed to "grow"; Rubens worked on wood panels, and it is known that he added two strips, one on the right to expand the sky and another at the bottom to provide more space below the hands.

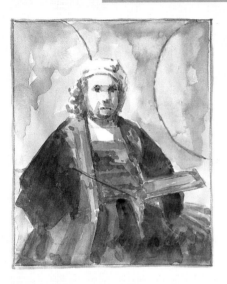

SELF-PORTRAIT

For anyone interested in portraiture, a study of Rembrandt's work is essential. This late self-portrait is one of his most powerful and moving paintings. The composition is an austere arrangement of abstract shapes, with the dark triangle of the figure balanced by the two circles in the background. No one has been able to explain the significance of these circles; they may represent something, but it is probable that Rembrandt put them there simply as a compositional device.

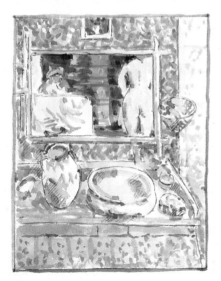

MIRROR IN THE DRESSING ROOM

Pierre Bonnard was a contemporary of Edouard Vuillard (see pages 46–7) and also painted intimate domestic interiors. In Mirror in the Dressing Room he has used the device of a reflected image both to frame the nude figure and to provide a context for it. The figure is the focal point, to which the eye is immediately drawn, but it does not dominate the composition at the expense of the delightful still life in the foreground.

DEMONSTRATION

ALTHOUGH I USE SKETCHES as visual reference for my portraits and figure groups, I always work direct from the subject when painting landscape and usually complete a painting in one day unless bad weather necessitates separate sessions. The other main difference between my two areas of activity is that much of my studio work is on a large scale (with the exception of still lifes), while my landscapes are small, whether in oil or watercolour.

For this study of Notre Dame in Paris I have chosen watercolour, as it enables me to work quickly. I like semi-opaque watercolour, which I achieve by adding gouache white to the colours. This thickens the paint slightly so that it is more controllable, but does not sacrifice the luminosity that makes watercolour such an attractive medium. The paintbox I use contains the following colours: black, Payne's grey, ultramarine, Prussian blue, alizarin crimson, cadmium red, burnt sienna, raw umber, cadmium orange, yellow ochre, viridian and gouache permanent white.

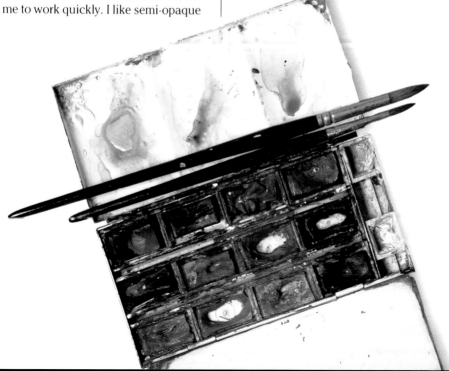

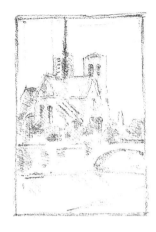

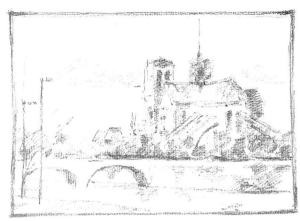

1 I start by making some small sketches to plan the composition. A vertical format was one option, but I decided on horizontal, as this allowed me to include more of the bridge.

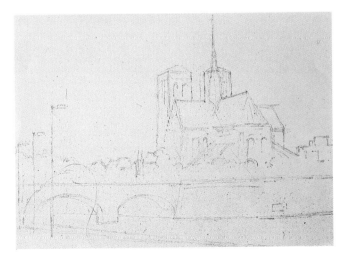

2 A careful drawing is needed for watercolours, as they are not easy to change. I am working on coloured paper, which is ideal for opaque watercolour.

61

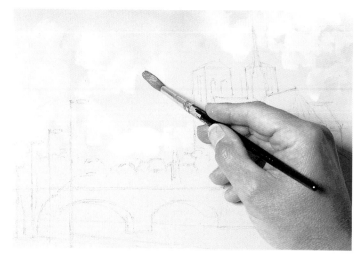

3 I begin with the sky, thickening the paint by adding just a little white gouache so that I retain the translucent quality.

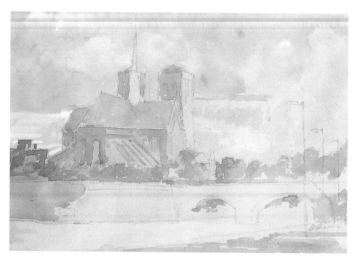

4 After about half an hour I have blocked in the main areas of colour, though they will be darkened and otherwise modified as I proceed.

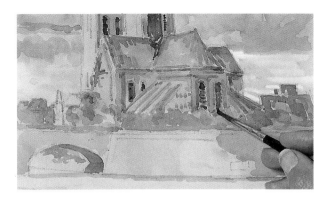

5 I now begin to add definition to the building, using small touches of dark paint.

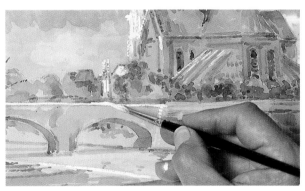

6 I use pure white for the top of the bridge and the parts of the building catching the light, but I apply it lightly so that a little of the yellow colour of the paper shows through.

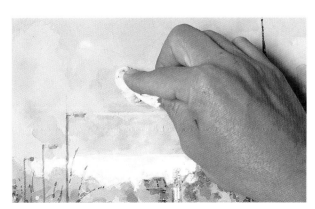

7 For the soft clouds I use a "lifting out" technique, which involves putting on paint and then pressing a piece of rag or tissue into it before it has dried.

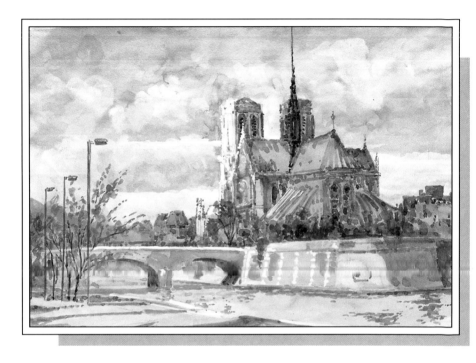

8 I have avoided putting in too many small details – what I wanted to express was the shape and solid bulk of the cathedral.